W9-CGY-510

CRAYONS

Henry Pluckrose

Photography: Chris Fairclough

FRANKLIN WATTS
London/New York/Sydney/Toronto

Copyright © 1987 Franklin Watts

Franklin Watts Inc
387 Park Avenue South
New York
N.Y. 10016

US ISBN: 0-531-10470-2
Library of Congress Catalog
Card Number: 87-50907

Editor: Jenny Wood

Design: Edward Kinsey

Printed in Belgium

The author wishes to record his thanks in the preparation of this book to: Hilary Devonshire for her help in the preparation of material; Christopher Fairclough for the excellence of his step-by-step photographs; Chester Fisher, Franklin Watts Ltd, for his advice and guidance; Roz Sullivan for her careful preparation of the typescript; and all the young people whose work he drew upon to illustrate this book.

Contents

Equipment and materials

In addition to wax crayons, this
book describes activities which
use the following:

Clips (large)
Candle (white)
Cardboard (thin)
Cardboard (heavy)
Coins
Corrugated cardboard
Cotton
Chalk (colored)
Electric iron
Glue and a glue brush
Jar or yogurt pot
Inks or cold-water dyes
Knife
Liquid detergent
Masking tape
Newspaper
Paintbrushes
Paint (powder color)
Paper – good-quality typing
 paper
 – construction paper
Paper towels
Pencil
Pencil sharpener
Scissors
Scraper tool blade and handle (or
 nail file)
String
Vegetable oil
Wallpaper

Getting ready

When I went to school (over fifty years ago) wax crayons were to be found only in the classrooms of the youngest children. It was as though no one believed that crayons had any place at all for older children who liked to draw or make pictures.

Times have changed. Today wax crayons are made in a wide range of colors, lengths and thicknesses. They can even be sharpened to a point with a pencil sharpener.

Crayons have advantages over many other picture-making materials. They are cheap, easy to carry and may be used right out of the package. The colors are easily mixed. Once applied, they require no fixing.

The most interesting thing about the crayon is that it can be used in so many different ways. This book describes basic crayon activities and suggests some simple ideas for you to try out.

Before you begin, remember that art activities can be messy!

If you are using this book at home, take all the precautions you would take at school. Cover the table with newspaper (and, if dyes or inks are being used, cover the floor too). Remember also to cover yourself. An old shirt or blouse, particularly if it is many sizes too big, will give you protection from head to toe.

An electric iron is required for some processes. Do not use an iron without first obtaining permission from a responsible adult ... and never leave an iron plugged in when it is not being used.

Many of the techniques require you to use inks or dyes. It is recommended that you use inks. Inks are sold in screw-top bottles and are easy to store. A recipe for dyes is given at the end of the book.

There are many different types of paper. If a technique fails, don't give up. Try the process again on paper of a different color or one which has a different kind of surface.

Successful picture-making depends upon you, the artist. Once you have learned how materials behave, experiment for yourself. Being creative is not just following instructions. The creative person takes an idea and turns it into something which is his or her own.

Trying out your crayons

The best way to come to know how materials behave is to doodle with them.

Take a piece of paper about the size of a page of this book and make a pattern on it with your crayons. Discover how hard you need to press to apply a heavy layer of crayon and how fine a line you can obtain by pressing lightly. Experiment by mixing several colors together.

Find some different types of paper. Crayons are not as easy to apply on rough paper as they are on smooth paper. How does the color of the paper affect the color strength of the crayons?

When you have learned something about your crayons, you will be ready to draw. At first it's fun to use all the colors and if you have a full color range you probably won't need to try mixing one color with another.

There comes a time, however, when it's worth setting yourself a problem. Could you, for example, make a picture using only black and white crayons? Could you make a picture using only yellow, red and orange crayons?

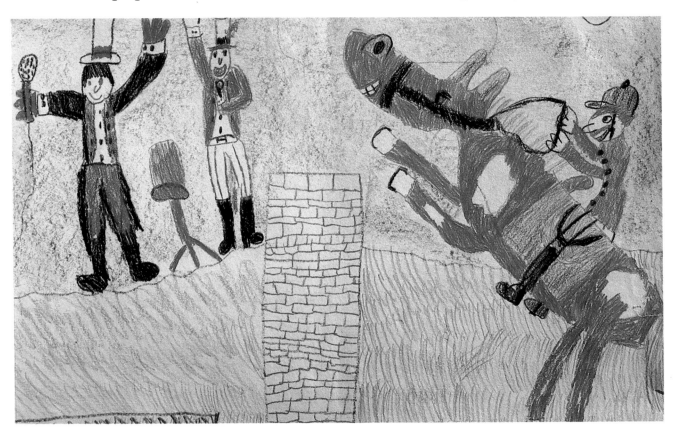

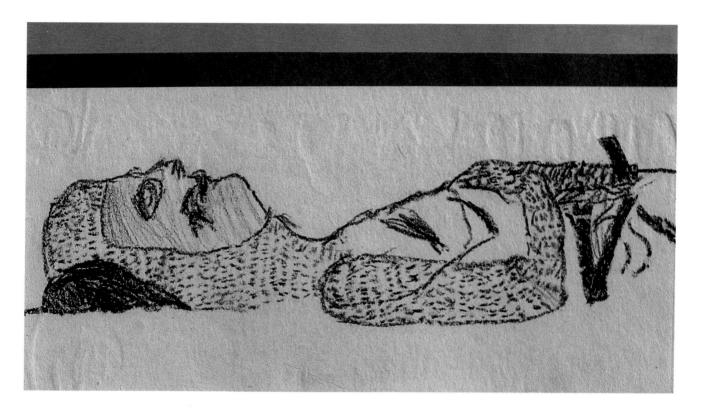

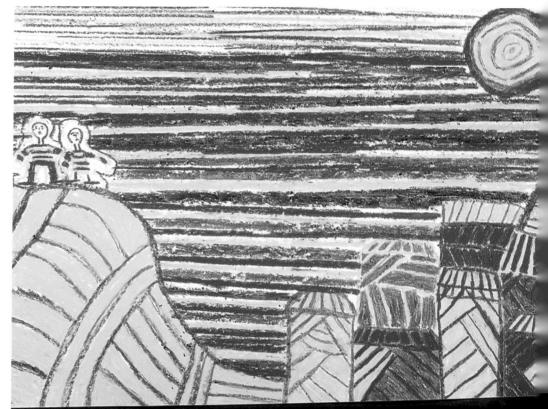

1 (Opposite)
Show-Jumping
A drawing using a full
range of colors.

2 (Above)
The Dead Knight
A drawing in black
crayon.

3 (Right)
Magic Town
A drawing using a
limited range of colors.

To make a pattern using a crayon "comb" you will need a thick crayon and a sharp knife. (Handle the knife very carefully.)

Attractive patterns can be made by using two or three different colored crayons for each design. For example, if red and yellow crayons are used for the "combs", the final pattern will be in red, yellow and orange; while yellow and blue crayon "combs" will give a pattern in blue, yellow and green.

Paper decorated in this way can be used for book covers, for wrapping gifts and for place mats and table decorations for parties.

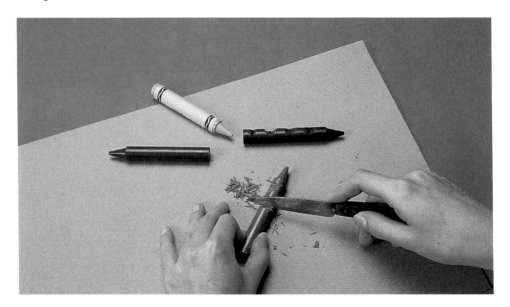

1 Peel off all the covering paper from the crayon. Using the knife, cut V-shaped notches along one side. Make sure that you cut no deeper than half the thickness of the crayon.

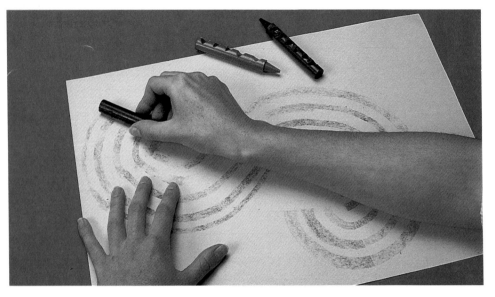

2 Holding the crayon firmly, move the notched edge across a sheet of paper. It will produce a series of parallel lines. Experiment by moving the crayon across the paper in a circular motion and in twists and twirls.

3 (Opposite) The finished design.

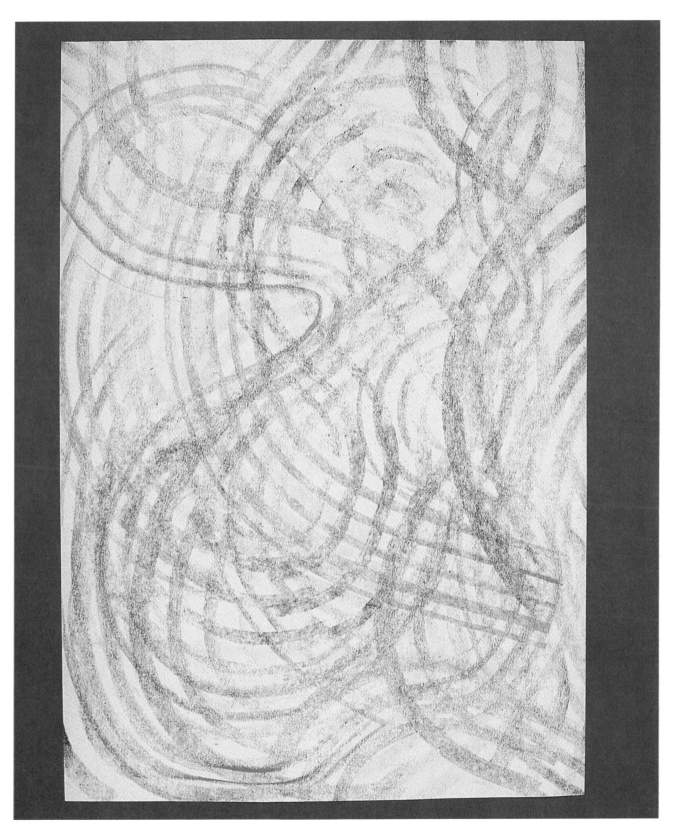

Crayon resists

Wax does not mix with water. Wax resists water. Knowing this can be used as the starting point for a series of experiments in picture-making.

To make a crayon resist picture using a range of colors, you will need a sheet of construction paper, wax crayons, ink or water-based dye and a paintbrush.

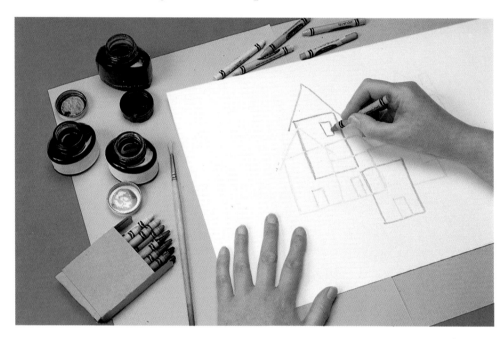

1 Draw a picture in crayon. Choose bright colors e.g. green, yellow, orange, red.

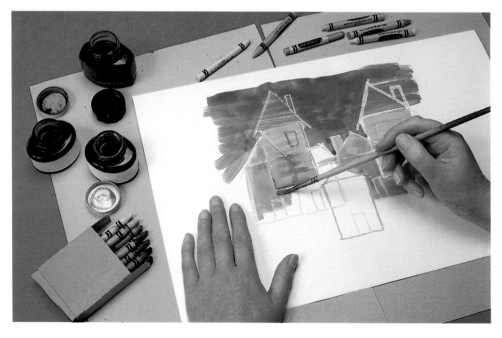

2 Complete the picture by applying the ink or dye and brushing it lightly across the whole of the design. This ink wash will color the paper that is unprotected by the wax. Where there is wax the ink will be resisted (or repelled).

3 Single color resist. Follow the same procedure, but this time draw the design with a white crayon (or candle) on white paper.

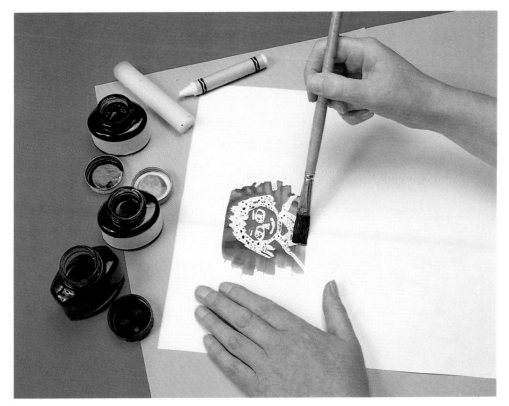

4 Brush ink (or dye) over your white line design to reveal your picture.

5 *Greek Horse*
White crayon drawing
on white paper,
resisted with black
dye.

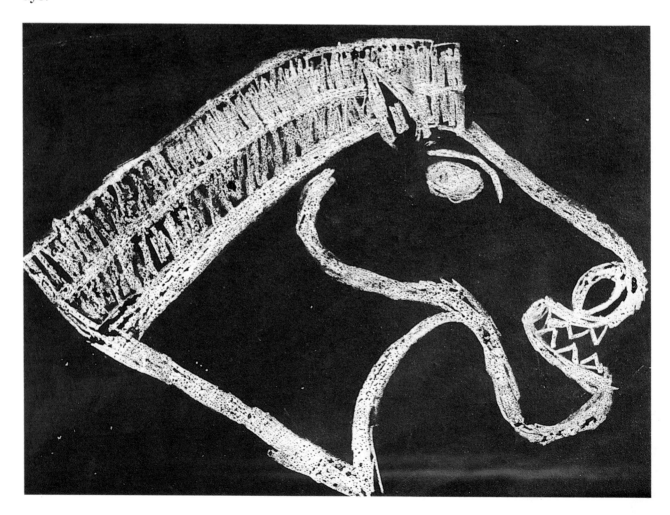

Paper Batik resists

You will need a sheet of cartridge paper, wax crayons, ink or water-based dye, a paintbrush, a paper towel, some newspaper, two clean sheets of paper to protect your picture and an iron.

When you have made several pictures using this process, try a few experiments. Choose some different types of paper. What happens if you use a paper with a soft, absorbent surface? What different effects are achieved on a thick paper with a glossy finish?

You could also try using several colors at the inking stage – for example, blue for areas of sky, deep green for sea or landscape, yellow/orange for areas of earth.

1 Draw a picture in crayon. The crayon must be applied heavily and no paper should show through the design.

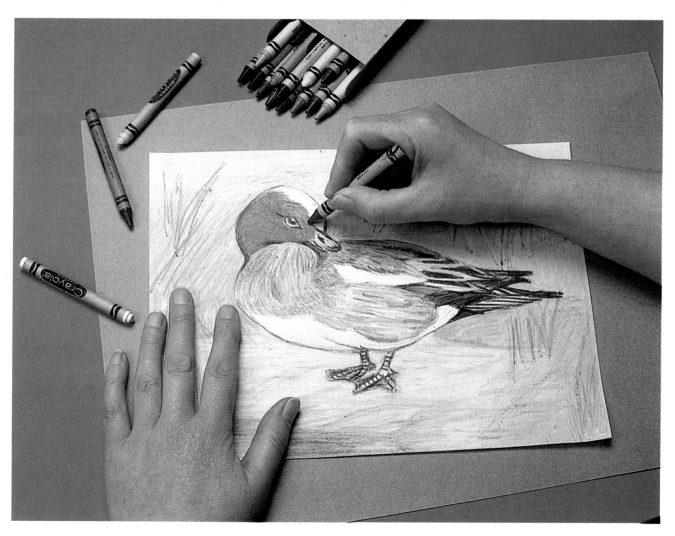

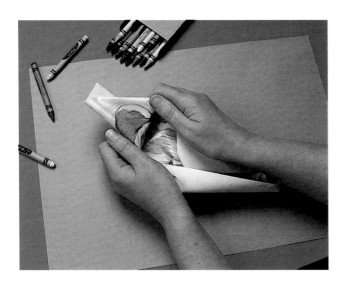

2 When the picture has been completed, screw it into a tight ball. This will cause the wax to crack.

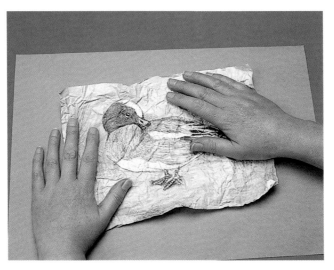

3 Now carefully smooth out the paper, taking care to blow off any small scraps of crayon dust.

4 Ink is added. Brush the ink firmly into the picture, making sure that the tiny cracks in the wax fill with ink. When the whole picture has been treated in this way, wipe off any surplus ink with a paper towel.

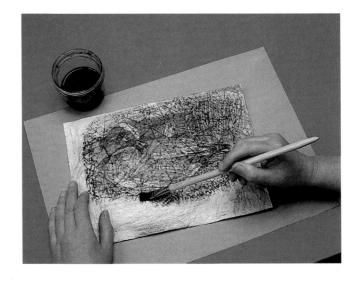

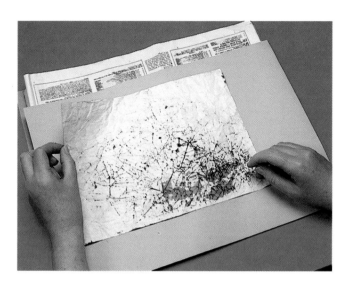

5 This process produces a somewhat crumpled picture. The creases can be removed by ironing. Place the picture between two clean sheets of paper on a thick fold of newspaper.

6 With the iron set to moderately hot, iron the picture.

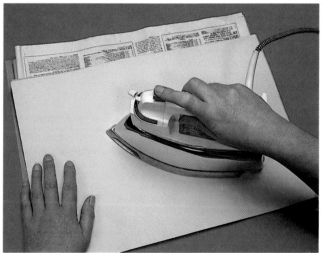

7 Examine the picture during ironing to check that creases are being removed.

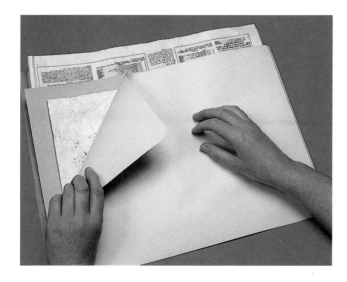

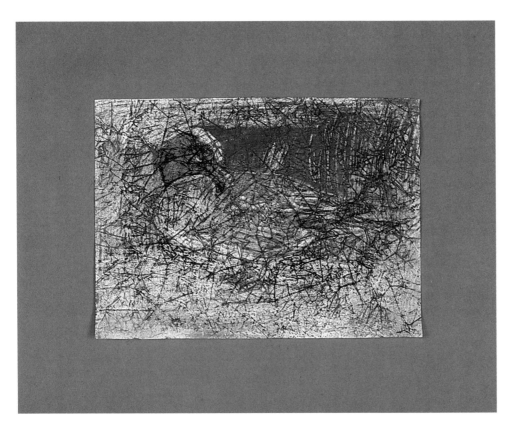

8 The finished picture. Remember to switch off the iron and put it in a safe place before you begin your next picture!

9 *The Angry Bee* Notice how the cracked wax filled with ink gives an interesting texture to the picture.

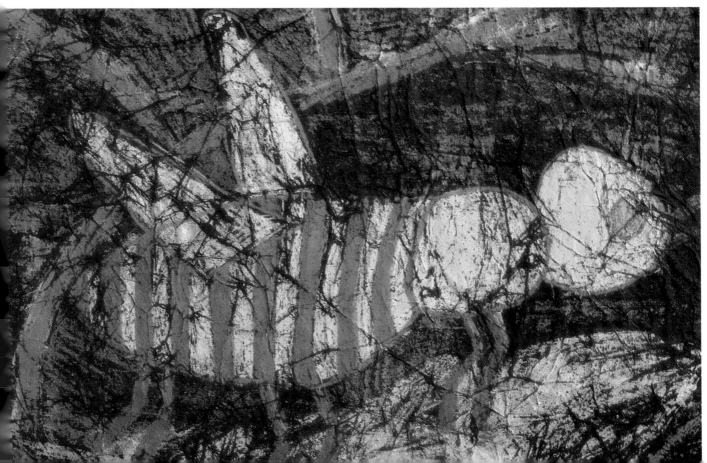

10 *Wake Up*
Here the background has been covered with white crayon. Notice that the hot iron has caused the bright colors of the cockerel to blend together.

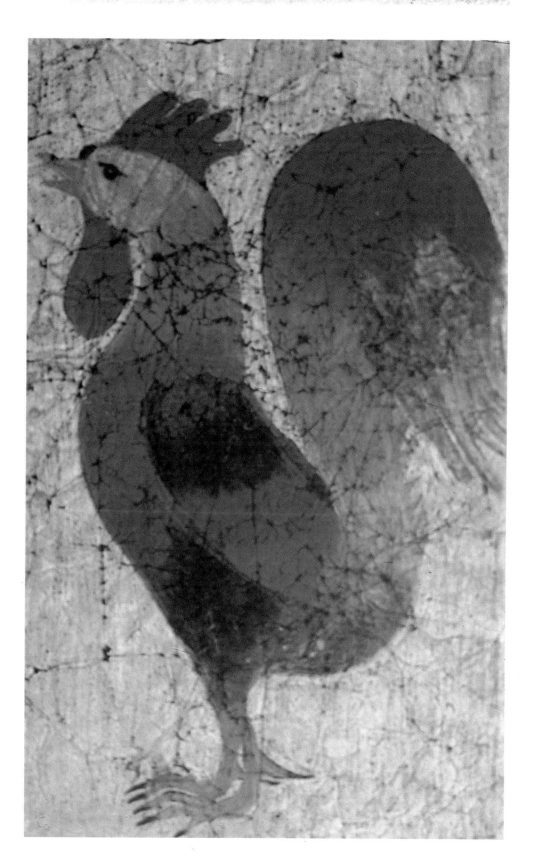

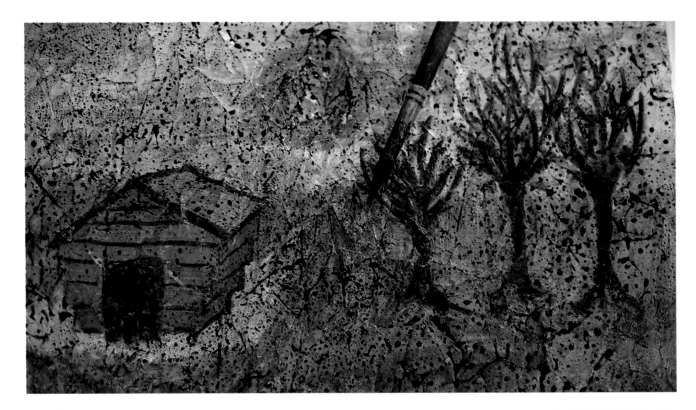

11 *The Hot Forest*
When choosing colors
for a paper batik
picture, always try to
imagine what the final
effect will be. Very
dark crayons crack
just as easily as lighter
ones. But how clearly
will dark ink or dye
show against dark
crayons?

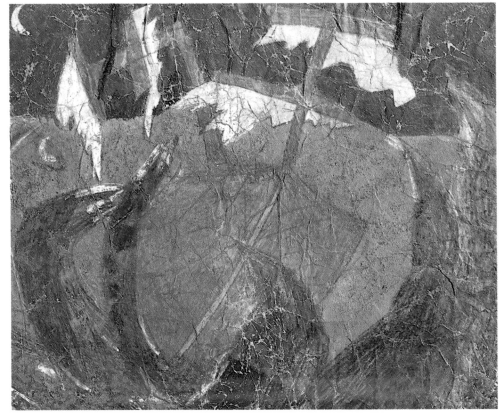

12 *Storm at Sea*

Crayon windows

For this you will need a sheet of good-quality typing paper, wax crayons, a piece of absorbent cotton and a small quantity of vegetable oil.

Stained-glass windows are made of small pieces of colored glass held within a frame of lead. Although these are not "true" stained-glass windows, it is possible to make pictures that look like the real thing.

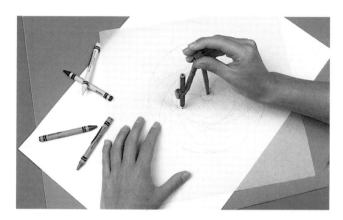

1 Draw a design in black crayon, heavily applied on to the paper. These black lines will represent the lead framework found in a stained-glass window. Your design could be abstract (that is, a pattern) or, like many church windows, it might illustrate a story.

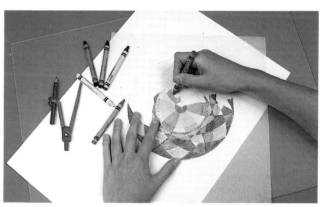

2 Color the spaces between the black "lead" lines in bright colors – red, blue, green, yellow, purple, orange. No paper should show through.

3 When this stage is completed, turn the paper over. Using a wad of cotton, rub vegetable oil into the back of the design. This will make your paper glow when displayed against a window where it can be lit by the sun.

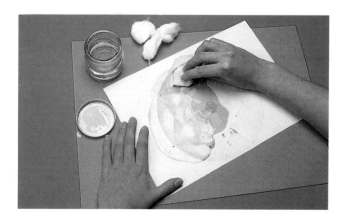

4 The completed
design displayed
against natural light.

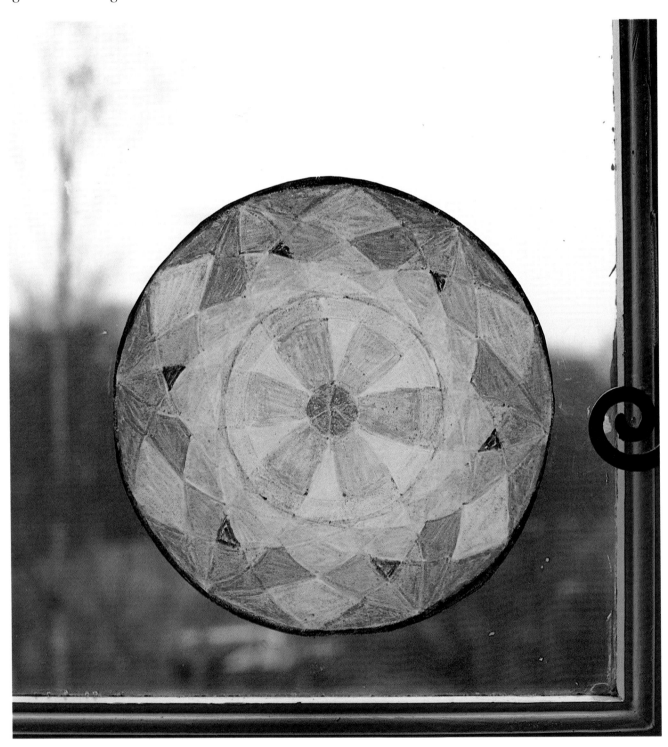

This method of making a picture builds upon some of the processes which have been considered earlier in this book.

You will need a small sheet of construction paper, a piece of chalk, wax crayons, ink or water-based dye, a paintbrush and a paper towel.

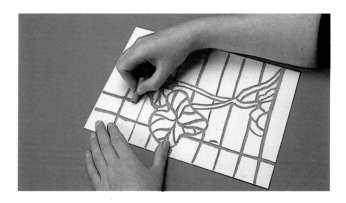

1 Draw a design in chalk to fill the paper. Your name would do very well. Apply the chalk thickly.

2 Now color all the paper that remains (i.e. where there is no chalk) with crayons of different colors. Apply the crayon heavily.

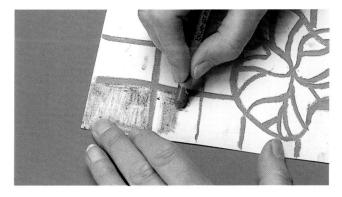

3 When all the paper has been covered, brush the ink or dye over the whole picture. The chalk will suck up the ink, the crayon will resist it.

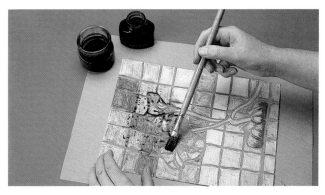

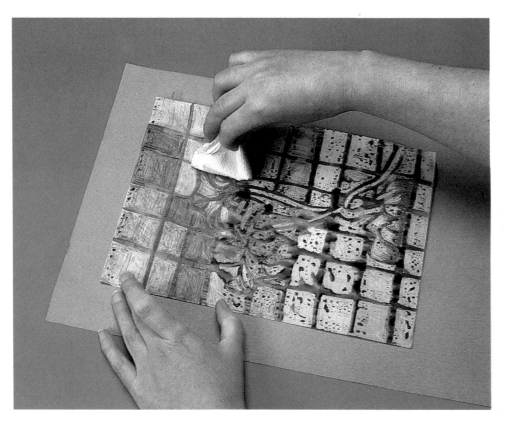

4 Finally, wipe the picture with a paper towel to remove any surplus ink. The chalked lines will appear dark (the color of your ink). The crayoned areas will shine through in their original colors but will be slightly textured by the ink.

5 A chalk and crayon resist using letters.

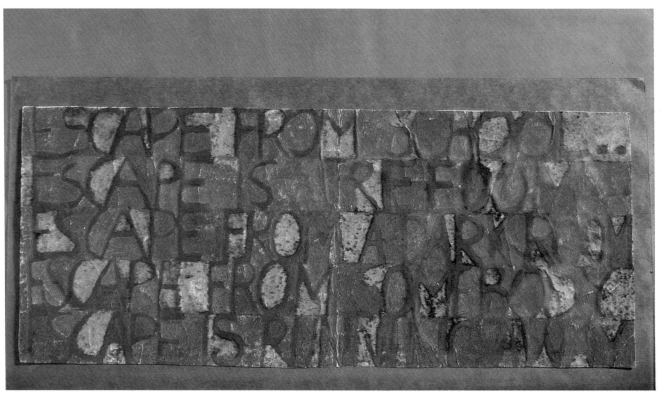

6 *The Town*
An abstract design in
chalk and crayon
resist.

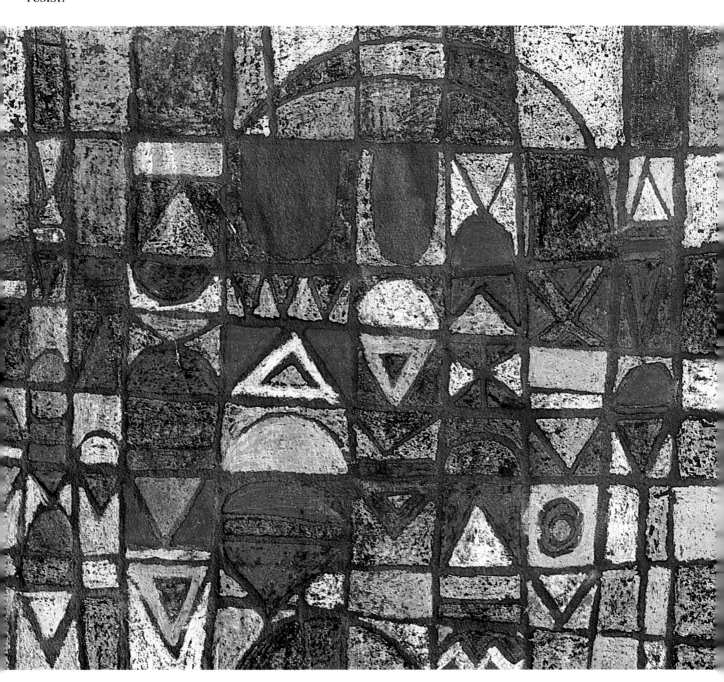

Color cutting in crayon

To make a color cutting in crayon you will need wax crayons, a small piece of construction paper (20 cm × 25 cm; 8½″ × 11″) and a scraper tool (or nail file).

From the photographs, you can see that pictures are made by cutting into crayon. This means that any mistakes made in your drawing can be corrected easily. Simply black out the mistake with crayon and start again.

1 Cover the paper with a layer of light-colored crayon. Apply the crayon heavily so that no paper shows through.

2 Apply a second layer of crayon over the first. This second layer should cover the first color so that it disappears completely.

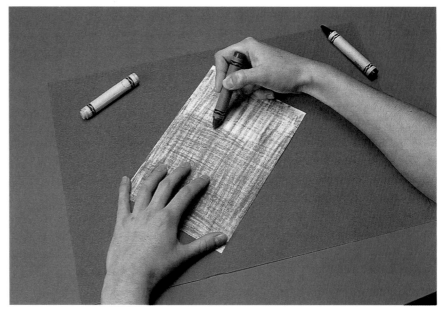

3 Now apply a third layer, this time using a black crayon.

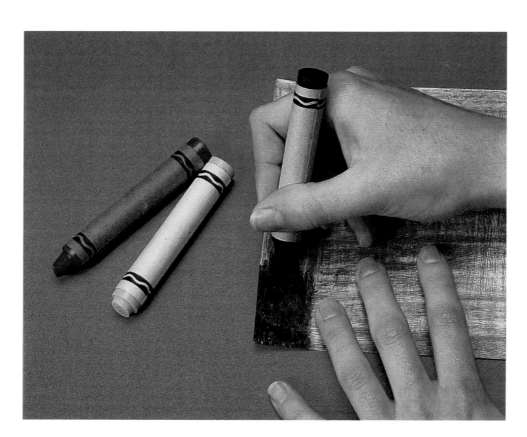

4 Using a scraper tool or nail file carefully cut a picture into the black surface. As the black crayon is removed, the colors you used for your original pattern will show through the lines of your design.

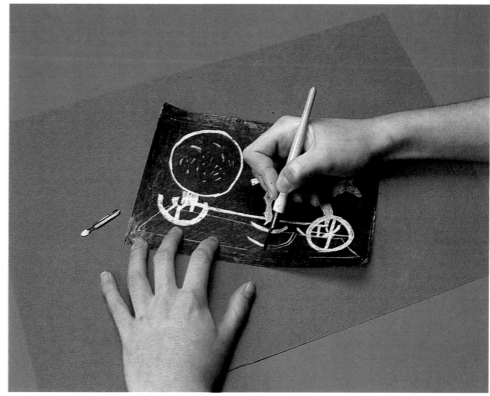

This process is very similar to cutting in crayon.

You will need wax crayons, a small piece of construction paper, a scraper tool (or nail file), a tablespoonful of black powder paint, a jar or yogurt container, three tablespoonsful of liquid detergent and a paintbrush.

As with cutting in crayon, any mistakes made during cutting can be corrected easily. Simply paint out the mistake with your detergent and paint mixture, leave it to dry then start again!

It is not essential to use black paint. What effect would you achieve if you made a pattern in light crayon on black paper and cut the design into a mixture of liquid detergent and white paint?

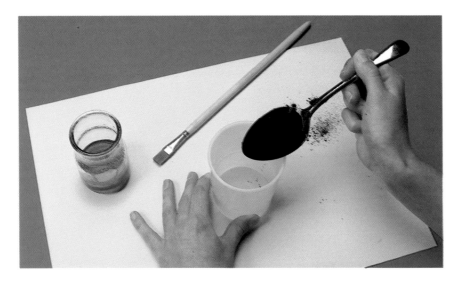

1 Mixing the paint. Put the powder color into a jar.

2 Add the liquid detergent and stir briskly. The final mixture should be as thick as heavy cream. If it appears too thin, add a little more powder. If it appears too thick, add a little water.

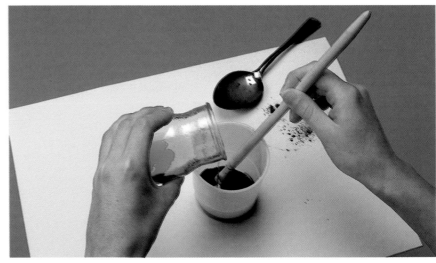

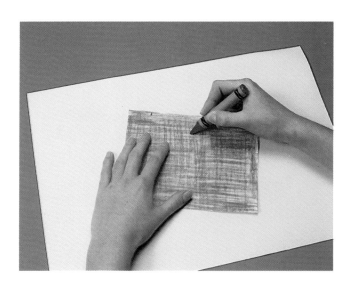

3 Cover your paper with a pattern in light-colored crayons heavily applied.

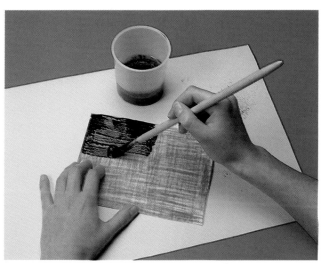

4 Now brush the detergent and paint mix over the pattern so that the pattern disappears completely.

5 When the paint has dried, cut a picture into the surface with a scraper tool or nail file. As the paint mix is removed, the colors you used for your original pattern will show through the lines of your design.

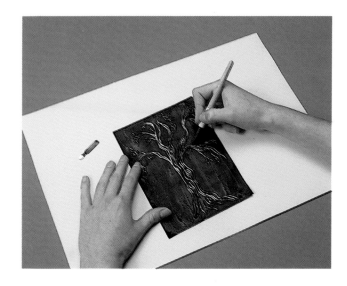

6 The finished
picture.

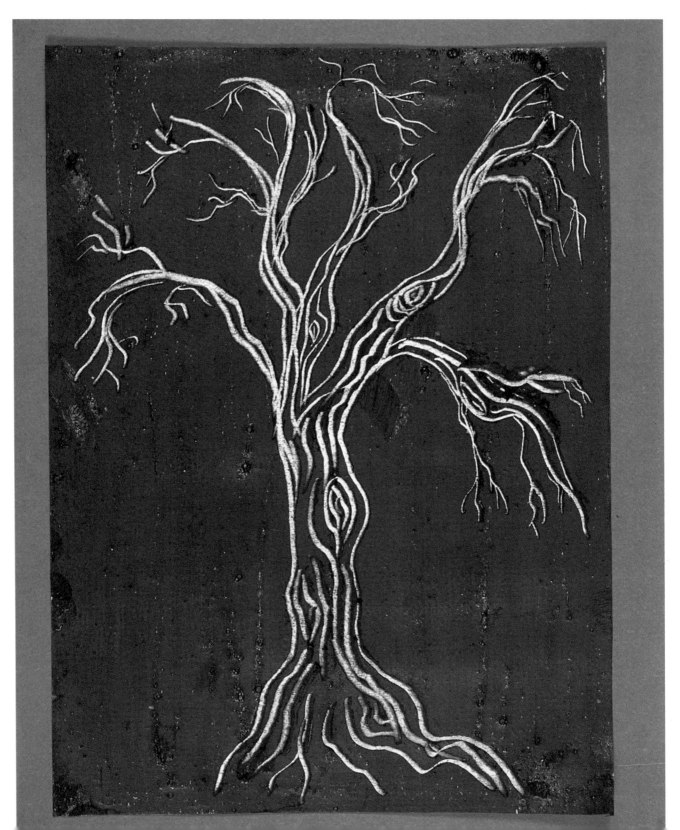

For this you will need colored chalk, wax crayons, a pencil and a sheet of white paper.

As you can see from the photographs this method produces two pictures. One is a line drawing. The second is a transfer drawing cut into the surface of chalk and crayon. Before you try to do a large picture it is wise to experiment using a small sheet of paper. This experimental picture will teach you the process – and show the various ways in which chalk and crayon blend together.

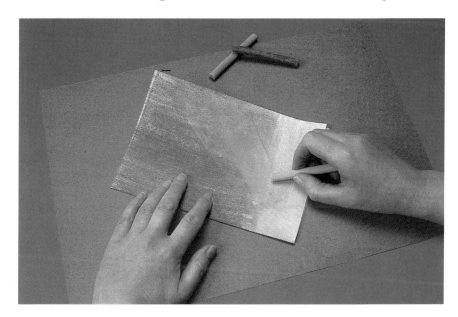

1 Fold the paper in half. Cover this half sheet with a thick layer of colored chalk. No paper must show through. Brush off any chalk dust. Now cover the chalk with two layers of crayon. Use a light-colored crayon for the first layer (e.g. yellow, pink, orange).

2 Apply a second layer of crayon in a darker tone. These two layers of crayon must cover all traces of the chalk.

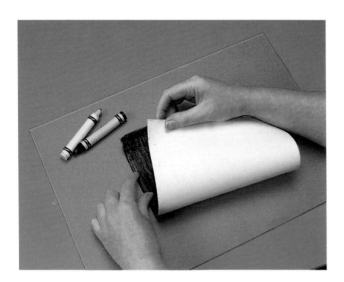

3 Refold the paper so that the crayoned and chalked sheet is covered by the half which has not been colored.

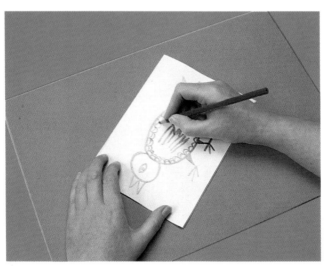

4 Press firmly and draw a design on to this.

5 When your picture is finished, open the fold. The original picture will appear twice – once as a cutting into the crayon and once as a colored transfer. (Do not use letters or figures in your drawn design. Can you think why their use should be avoided?)

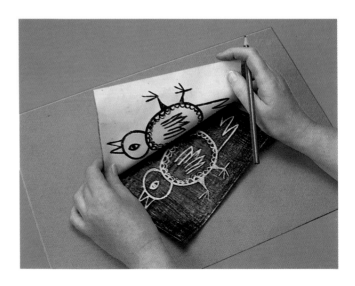

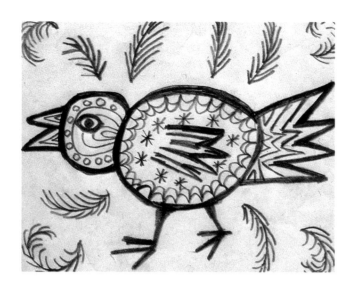

6 The drawn design.

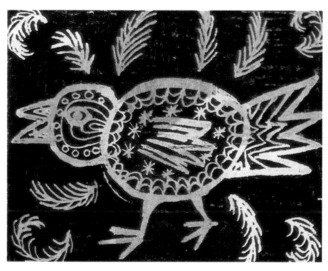

7 The transfer on to the paper on which the chalk and crayon was applied.

8 The reverse side of the drawn sheet (a reflection of photograph 7).

Rubbings

Have you ever put a coin under a piece of paper and scribbled over it with a pencil to obtain a picture (or "impression") of the coin? The impression is called a rubbing – the transfer on to paper of the raised and textured surface of the coin.

Crayons are excellent for taking rubbings. Why not build up a collection of rubbings of your own? You can make rubbings from natural objects (like stone, the bark of trees, leaves, shells) or from man-made objects (like brick, textured papers and cardboard, metal, plastic).

To take a rubbing, place a sheet of paper over the surface you wish to "record". Holding the paper firmly, apply the side of the crayon in even sweeps across it (see photograph **1**). If you are taking the rubbing of a large object (like the inscription on a tomb) it is best to fix the paper in place with masking tape.

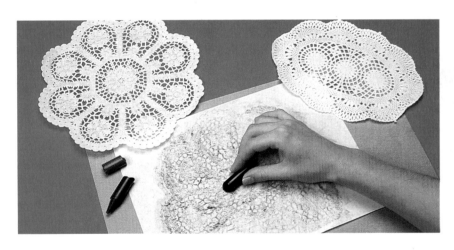

1 Taking a rubbing from a paper doily.

2 Rubbings from metal.

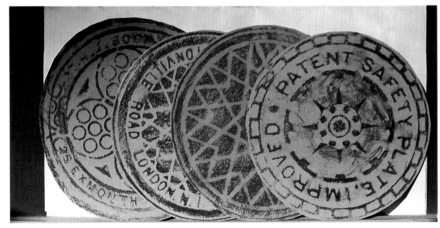

Making the board

To make a rubbing board you will need two small sheets (30 cm × 25 cm; 12″ × 11″) of thin cardboard or thick paper, a pencil, a pair of scissors, glue and a glue brush.

On one of the pieces of card, draw a simple design (for example a house, a fish or animal). When you have completed the design, cut it out and glue it on to the second piece of cardboard. You now have a board in two layers – the base sheet and your cut-out design. Now think of ways of adding to the design by adding more pieces of card. For example, if you have made a house you could add windows, doors, a garden fence and some trees. If your design is of a cat you could add eyes, whiskers and a nose. The aim is to build up a surface in three or four layers of card which, when rubbed, will produce an interesting picture.

1 Designing a board for rubbing.

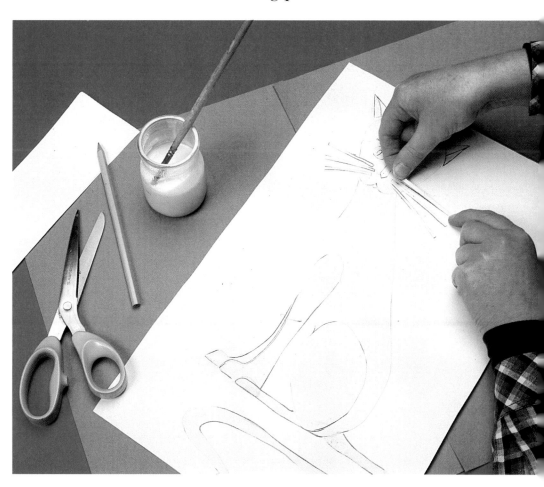

2 The finished board.

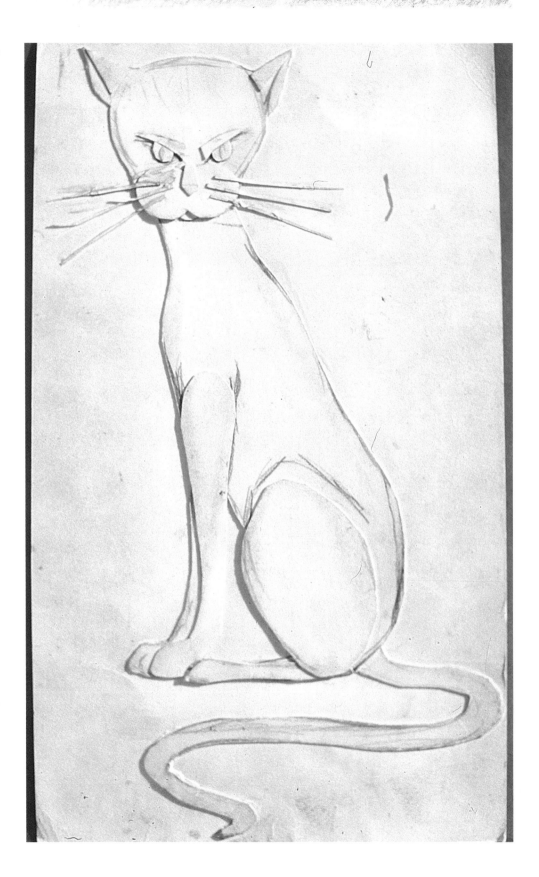

Taking a rubbing

Place a sheet of paper over your board. Fold one edge under the board so that the paper will be held firmly in place. Choose a dark-colored crayon and, using it lengthwise, rub it evenly across the paper. Your design will show through.

1 Place the board in a "fold" of paper.

2 Rub the design through the paper with a crayon.

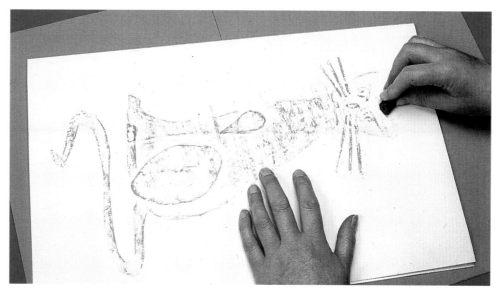

3 Build the board in
several layers.

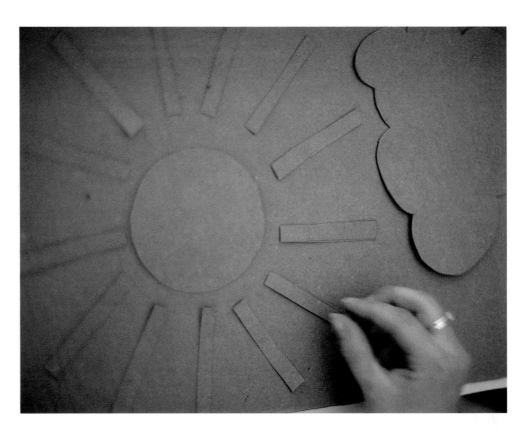

4 This will give depth
to the final rubbing.

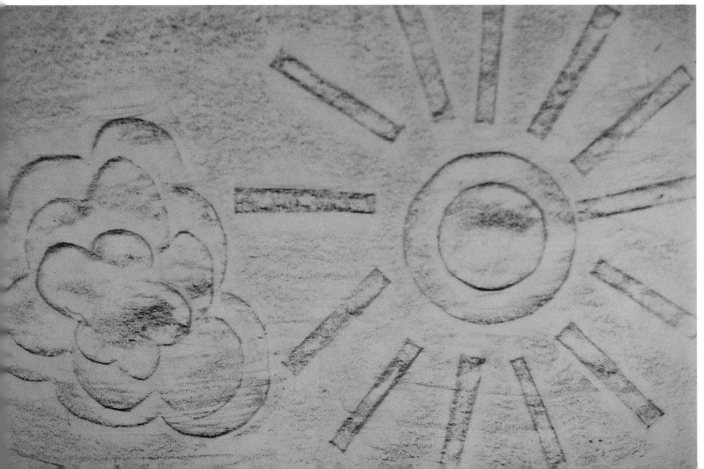

5 *Lion*
The base board for this was designed so that the pieces of card were mounted with small gaps between each section. These give lighter lines when the board is rubbed.

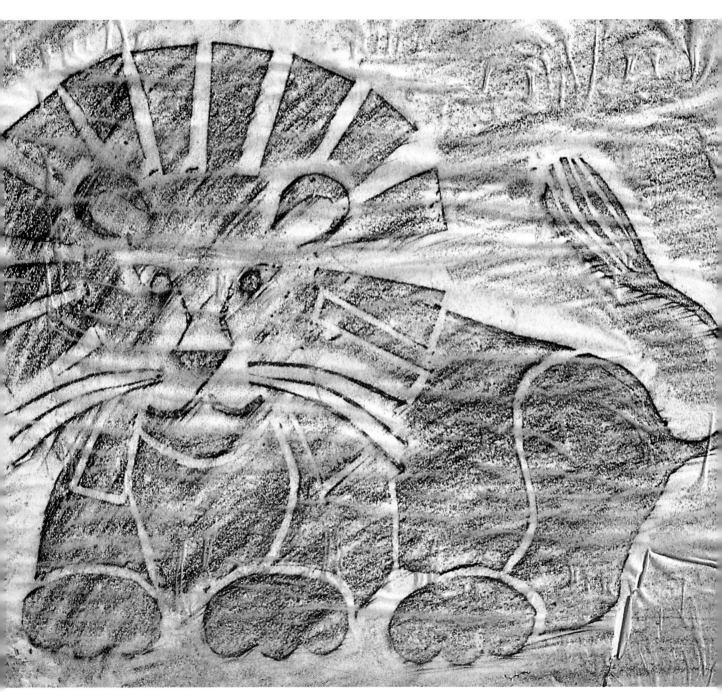

Patterns from rubbings

Here are some ideas for varying the pictures you can make from one rubbing board. By focusing on one section of your board, for example, you can build up a new and more unusual pattern. Another way of creating a new picture is to combine different parts of your original design.

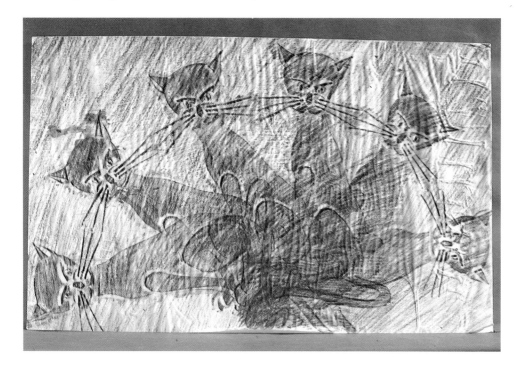

1 Make a rubbing of your design in a light-colored crayon. Move the board slightly and rub again. By repeating this process you can make an unusual picture from one board.

2 Choose a small part of your board. Make a rubbing of this section.

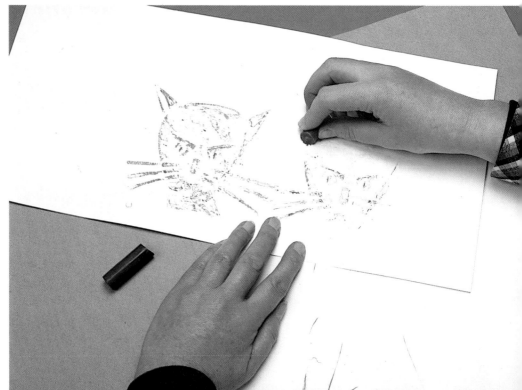

3 Move the board. Take another rubbing of your chosen section. Repeat this process to build up a picture.

4 Make a rubbing of your design in a light-colored crayon. Without moving the board, go over part of the design with a darker crayon to emphasise some part of the design.

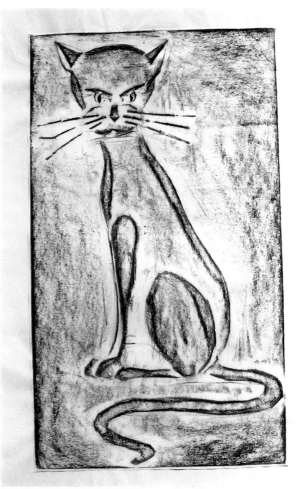

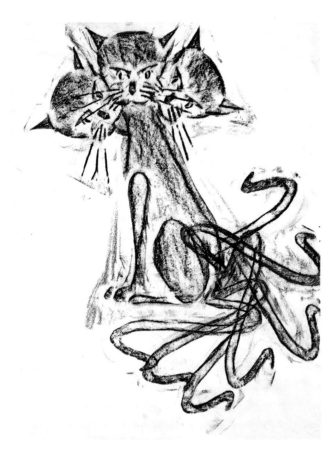

5 Now try to combine different parts of the design to make a new picture.

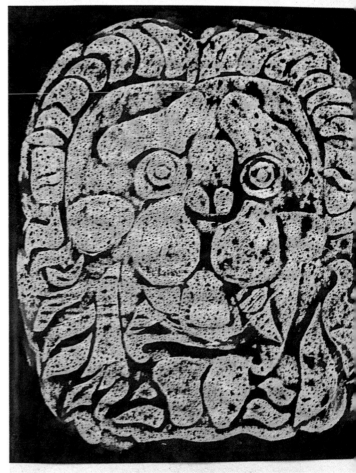

6 *Lion's Head*
A rubbing in yellow crayon resisted in black.

Before you set out, check that you have:

1 Sheets of colored paper. Choose colors which fit the sorts of things you hope to draw.
2 Thin crayons in a range of colors and a pencil sharpener so that you can shape the crayons to a fine point if necessary.
3 A board (heavy cardboard or hardboard) on which to rest your paper as you draw.
4 Two large clips to hold the paper on your board.

Your outdoor sketches (or sketches made in museums and galleries) can be used for some of the techniques you have learned in this book. For example, you could add colored inks to a line drawing or copy a drawing you have made by cutting it into wax . . . and almost every picture you make will provide an idea for a card design from which you could make a rubbing.

If you go on a sketching expedition it is best to go with a friend. Tell a responsible adult where you are going, how long you are likely to be away and with whom you will be.

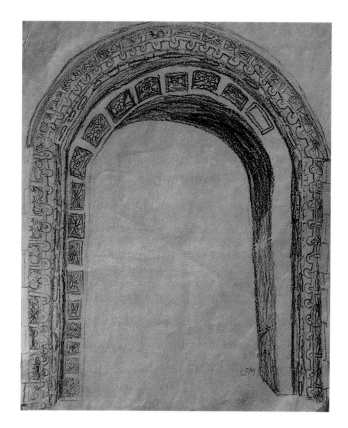

1 (Above) A Norman arch drawn by a ten-year-old.

2 (Below) This picture of a sailing boat was drawn by a child of seven.

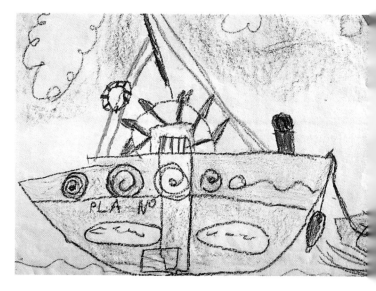

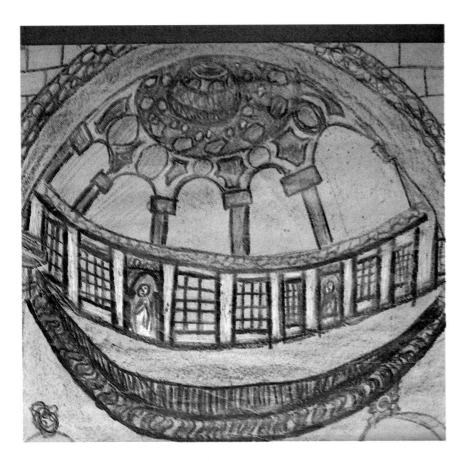

3 St Paul's Cathedral in London drawn by a ten-year-old.

4 A steam engine, drawn by a seven-year-old. The picture was drawn in white crayon and then resisted.

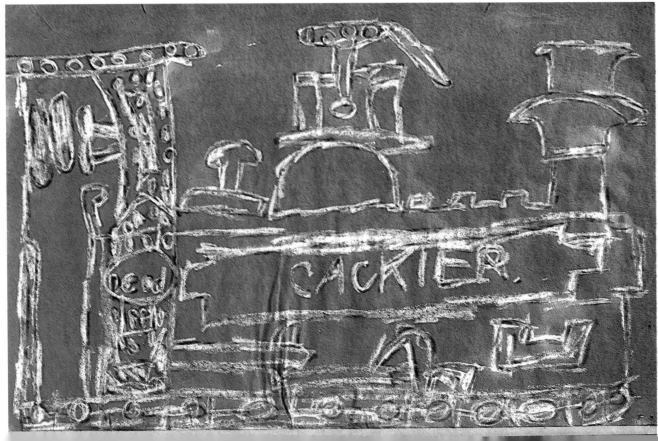

Throughout this book you have been experimenting with crayons. By doing this you have learned some of the ways in which crayons behave. Now try some ideas of your own. Here are some suggestions to help you.

1 Could you make a picture which combines two or more of the ideas in this book? For example, make a rubbing (from any material or a board) and then use it as the starting point for a paper batik (see pages 13–18).

2 Could you build up a picture over a simple resist? To do this you must first make a resist picture (see pages 10–12). When the picture is dry, add details in crayon to parts of your design which have been dyed. Now fill in some of these areas with dyes of different colors. A hint – always use a light-toned dye for your resist picture (see photograph **2**).

3 Make a rubbing board (see pages 33–37) of cardboard and papers of different textures and thicknesses. For example, try to design a board which includes paper, thin cardboard, scraps of wallpaper and corrugated card.

4 Using PVA adhesive, make a pattern by gluing leaves face side down on to a piece of cardboard. Use this design for a rubbing

1 Chalk crayon and dye design. What other technique has been used?

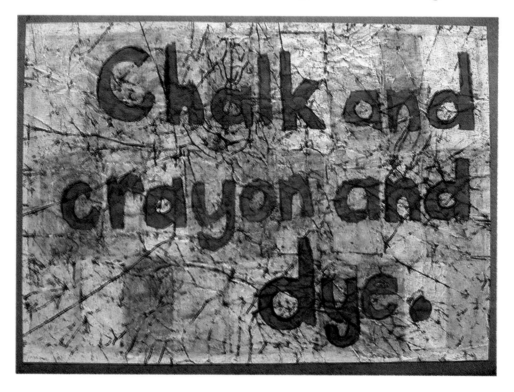

board.
5 Coat a small square of card with a thin layer of adhesive. While it is wet lay a length of fine string on the wet surface. Arrange the string in loops and curls to make a design. When quite dry, use for rubbings.
6 Make notices and posters using chalk and crayon resist (see photograph 1).
7 Make a geometric design using a pencil and a pair of compasses. Color the design in crayon, then resist with ink or dye (see photograph 3).

2 Use dyes of different colors to build upon a resist picture.

3 A geometric design used as the starting point for simple resist.

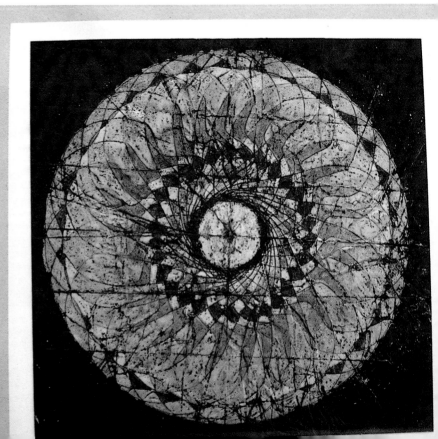

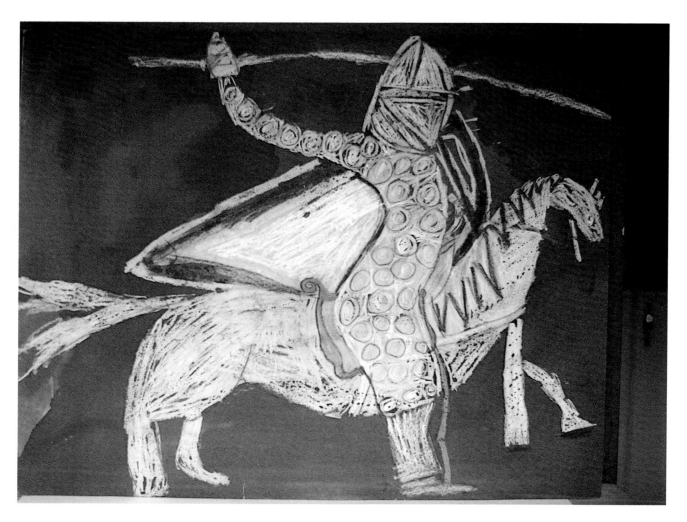

4 *Norman Knight*
Silver crayon and dye.

5 *Old Town*
Chalk and crayon
resist.

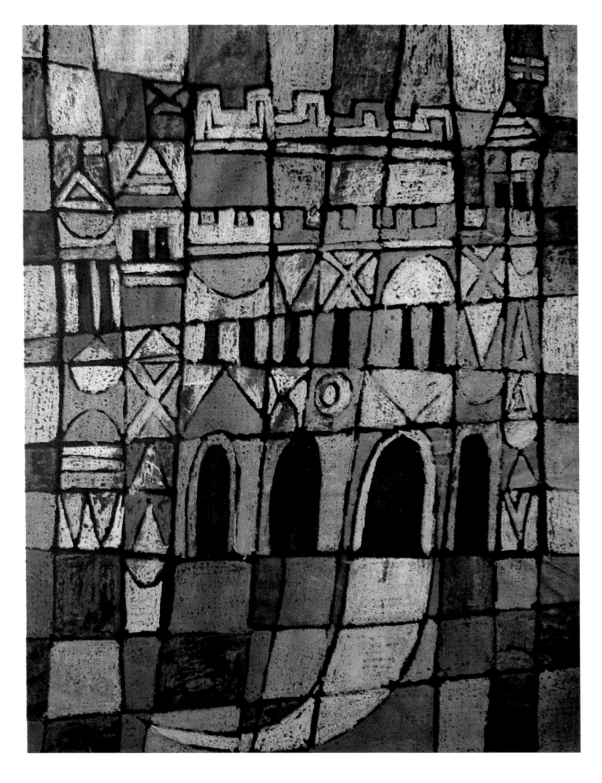

Brushes

White hog-hair brushes, which are hard-wearing and comparatively cheap are most suitable for resist and batik work. Sizes 6, 8 and 12 are recommended for the activities included in this book (size 6 for small-scale work, size 12 for large-scale work).

Dyes

Dyes are good sources of color.

Here is a formula for using cold water dye. Open a packet and pour the powder into a clear jar. Add approximately 300 ml (½ pint) of cold water and stir until all the powder is dissolved. If the color is too thick when it is used for resist it can be thinned with water. Made in this way, dye can be stored indefinitely.
(NOTE: All water-based dyes can be intermixed to produce additional tones and colors.)

Ebony stain

This is a black stain which is very suitable for all types of resist work. It can be thinned with water and is easily washed off hands and clothes. It is obtainable from most shops which sell artists' materials.

Papers, cutting tools, card, adhesive

Stationers carry the majority of the materials listed in this book. All the materials can be obtained by ordering through a school supplier.

Wax crayons

Good quality wax crayons are made in a wide range of colours (including gold, silver and bronze) and thicknesses. They are obtainable from shops which sell artists' materials and from stationers and department stores.

PRINTED IN BELGIUM BY

proost
INTERNATIONAL BOOK PRODUCTION